GATHERING A LIFE

Gathering A Life

A Journal of Recovery

JEANNE LOHMANN

JOHN DANIEL & COMPANY · SANTA BARBARA · 1989

The author and the publisher wish to express their gratitude
to the National Brain Tumor Foundation for its
encouragement and support.

Design and typography by
Jim Cook/Book Design & Typography

LIBRARY OF CONGRESS CATALOGING-IN-PUBLICATION DATA
Lohmann, Jeanne.
 Gathering a life / Jeanne Lohmann.
 p. cm.
 ISBN 0-936784-77-6: $7.50
 1. Lohmann, Jeanne—Biography—Family. 2. Authors,
American—20th century—Biography. 3. Brain—Cancer,—Patients—
United States—Family relationships. 4. Husbands—United States—
Biography. I. Title.
PS3562.0463Z467 1989
818'.5403—DC20 [B] 89-32034 CIP

Published by John Daniel & Company
Post Office Box 21922, Santa Barbara, California 93121

Distributed by Texas Monthly Press, Inc.
Post Office Box 1569, Austin, Texas 78767-1569

For Hank.
For both of us,
and for Stephen, David, Karen, and Brian.

> What I am learning to give you is my death
> to set you free of me, and me from myself
> into the dark, and the new light.

<div align="right">

WENDELL BERRY
(The Country of Marriage)

</div>

After his initial seizure and exploratory surgery,
the diagnosis was malignant astrocytoma: brain tumor.
Without treatment: a possible four months.
With radiation and chemotherapy: longer, but
uncertain.

From the three and a half years we had,
these fragments. A journal of recovery.

Gathering A Life:

● *Downhill*

Downhill

The nurse put it to her simply. "Sometimes they go downhill very fast."

It could be a blessing, but she felt small gratitude. Mixed, as everything was these days. The connecting vision came later in a sudden memory of that toboggan ride in Rocky Mountain foothills when the children were small.

A perfect night for sledding. No end to the falling miraculous flakes, or the hills waiting. The whole family together in the clear cold, long past bedtime. All of them piled on in snowsuits and caps, mittens that kept coming off, the wool crusty with ice.

Heavy on the slow push-off, they picked up speed on the slope, sailing out almost to the center of the night. He steered expertly, seeing well ahead until that single tree stood up. Close.

The toboggan glanced off sideways. No one really hurt. They fell into deep powder, shaken, laughing, the least bit bruised. Helping each other up, they dusted off the snow.

She had brought hot cocoa in a thermos, cookies. They ate in the station wagon, their breaths steaming the windows. Loading the toboggan—war surplus gear, and heavy—on top of the car, tying it on with thick clothesline rope, they drove home, singing all the way.

Here, at sea level, years away from the mountains, the nurse's words indicated maybe it was happening again.

Downhill very fast. The air black and brilliant, snow melting like tears on their faces. Hoping to get home safe through a night spinning with mysterious snow that changed all the time. The tree ahead looked impossible to

avoid, no matter how carefully they might maneuver. They would surely hit it head on, regardless of expert pulling on the ropes, or any balancing of momentum and distance, the weight of all their love holding on for dear life.

A Different Order

Here we go to UC Med
Ju-dah! Ju-dah!
Zap that cancer in my head
Ju-dah! Ju-dah Day!*

He never had a chance, the doctors said, and that precisely
was the one he took. Curiosity saved, he said, not courage.
Teachers were wrong about heroics, about bravery. But to
go in curious, that would be a different order of life
altogether. Paying attention to smallest details, he would
be an explorer, open to whatever might live here in
confusion and pain. If only he could care enough to wait
in that eager receptivity he'd heard belonged to the saints,
he might make it through. Living or dying, he just might
get there.

Curiosity, he thought, had to do with care for all things
ordinary and unusual. It had to do with taking risks, with
watchful regard for the extraordinary chances of discovery.
If you were merely brave, you closed the door. You held
together, but you kept possibilities away. You couldn't
learn much if you were too busy with courage.

Where he was going he needed to learn how to learn all
over again. Becoming a little child meant finding his own
curious heart, his old boyish inquisitive spirit. It meant
confounding adults and professionals alike with foolish

*Our route to the University of California Medical Center took us up Judah
Street in San Francisco.

questions and absurdities, putting unlikeness together in strange new ways, and hang the results. It meant being oblivious to stares, and "knowing" glances. New levels of unawareness.

He could handle all this because it was his life here on the edge. And he had no time now for anything but play. He would be simple and he would be curious, taking his chances where they fell, riding home on the long shot, the last, the only one he had.

Calendars

Three for Christmas. Whole books of new days, gifts of unimaginable time. She stared at numbers, words, the pictures: green Irish landscapes of stone, mist and the sea; Emily Dickinson's paradoxes and whimseys; quilt patterns evoking the heritage of women she didn't know. She thought of her grandmother's quilt on the bed they slept in now, in the good times.

She wanted to keep the calendars, but three were too many. Like three years waiting instead of one, one year by itself enough, and heavy with expectation. Without him who could be dead within the year, what was she to put into these empty boxes lined up in front of her? She might play with possibilities, but the future would come on its own terms, faithful only to itself.

Smoothing the pages, she tried to gather some shape of days and seasons. The months looked quite flat. Nothing broke through the empty squares. There was no message in Emily's formal lines. The quilts kept their patterns intact. Ireland's hills disappeared into fog, the gray boulders falling down toward the sea.

Mosaic

A child sorts small bits of stone and glass from a stucco
wall. Like jewels in the fairytales she loves, she divides
them by color, shape, size. One by one she holds the pieces
to sunlight, and they reflect amber, ruby, green, clearest
blue. She considers prying other stones loose from the wall,
adding new gems to her hoard, but all that shines here is
too much.

This is what she remembers of first pattern-making:
sorting, fitting edges together in a rough mosaic. And she
tells her counselor about this child she was, with her boxes
of colored glass. Elaine says, "You can't organize
everything."

Facing a different wall, the woman wants something she
can keep. She's gathering and sorting her life, picking up
the fragments, examining them in the light.

Where she lives stays a secret place. She wants all this
tumbling variety to turn into treasure. She hopes she can
make it fit, learn to handle the hard pieces, the broken
edges.

Caretaker

> He who loves the word as he does his own body
> can be entrusted with the world.
>
> —*Tao-te-king*

Carrying clippers to the park, he cuts wild blackberry
runners from bushes blocking the trail downhill to the
clearing.

Stumbling over a protruding piece of broken fencewire,
on the next day he brings a strip of white cloth and ties it
on as reminder, a small flag saying if it can be helped, no
one should get hurt.

He goes home with pockets full of discarded bottles and
empty cans. Let them be used again, over and over, melted
down and turned into new containers.

The world pulls in and his energies are less, but this is
the way he keeps his life. Caretaker he has been and will
be, watching over what he loves, straightening land he will
be leaving, turning toward it with tender attention.

His hands make the prayer of his heart: let the ground be
as easy to walk over as to go into.

Retrieval

When they reached the trees he let the dog off leash. He liked to whistle him back through the high grasses, liked to see his long ears flopping, his hound's body lengthening out close to the ground, the panting, almost-smile of his jaws when he raced toward them to be praised and petted.

Spring smells were everywhere, but he threw sticks and big pine cones anyway. He wanted the dog's ecstatic responses, his splendid dashes into weeds and the miner's lettuce, the proud retrievals.

Comforted by brevity and intensity, reminded of essentials, he felt the sweet sharp concentration of his own dying life. Into high spirits and energy. Into affection and humor and grace.

Alive and running. Bringing something home.

Falling Backward

A friend asked, "What in your life prepared you for *this,* for facing this?"

He said it was the time he fell backward off the hayrack that summer on the farm in Minnesota. A branch of the old elm caught him off guard, he could have been badly hurt, and he wasn't. As he was going down all he knew for sure was that he wouldn't be destroyed.

O, he could be thrown off the bales of hay on the road to the barn, he could be knocked off the course of his sweet life, the wagon go on without him. He might hit dirt faster than he thought, but he'd roll easy, he'd rest in the shade, have a long drink of water. He would be all right.

Because this had happened he trusted what was happening. He never said he wouldn't be hurt, he didn't say he couldn't die.

He said he knew he wouldn't be destroyed.

● *Messages*

Territory

He was everywhere in the big house they no longer lived in
on anything like the old equality. No more separate
territory, no respected and taken-for-granted his and her
places of individual life and work. He offered advice on
nutrition, referred her to essential mineral counts in
milligrams, suggested schedules she didn't want to accept,
couldn't follow. Sometimes she exploded, and he was hurt.
He was only trying to help.

His need brought him into the rooms where she wrote or
worked or slept, into the garden, into the cluttered
basement workshop he always intended to organize.
Anywhere she was, he wanted to be. Sometimes she found
another space, but he came there, came to ask another
question. She thought he looked like a question mark,
hunched over in uncertainty, bewilderment.

When she needed to prepare food he was in the kitchen.
His breakfast lasted until noon, then it was time for lunch.
By five he was back to make a milkshake and to feed the
dog. He had pills to count, a careful formula to fix for the
weekly plant watering, a continuing series of snacks. After
supper he washed the dishes, taking two hours to do what
she could've done in minutes. He listened to music while
he bent over the dishpan, his hands protected by large blue
rubber gloves. Then he prepared the night-time snack that
took a long time because he was so tired.

And before sleep he would ask her to read to him. Often
near midnight he would ask her to read. This was their
long-cherished habit; she couldn't say no.

Layers

He made his own armor, layer on protective layer, starting
with the long underwear he wore in and out of season.
When he asked what the weather was like, she urged him
to check for himself, and the slightest rustle in the trees
meant breeziness, a high wind coming, surely.

He pulled on a sweater, vest, windbreaker, gloves, scarf,
his blue beret, sometimes the black ski mask that made him
look like Darth Vader but kept his sinuses warm, then
sunscreen for any exposed part of his body. He kept away
from the street to avoid traffic fumes and he walked in the
shade.

Indoors he wore the knit cap she cut from an old pair of
longjohns, the leg-opening stretched to fit around his face
like a Viking helmet. The ankle cuff dropping back over
his head gave him the appearance of a very wise elf. His
last layer was the blue and white yukata his sister brought
from Japan, a soft, geometrically patterned robe that was
his final insulation, protection against an invader he
seldom mentioned by name. Since the surgery and
radiation and all the chemicals he seemed to be warding off
blows, defending himself against further insult or injury.

He wasn't embarrassed by these rituals, by any
arrangement for comfort, by anything that helped him to
do battle. When her embarrassment got in the way, his
reassurance humbled her. "If it gives somebody a laugh,"
he said, "that's fine."

Learning

He is learning it over, learning it new, how to say I love you. With no trace of embarrassment he looks into her eyes, wanting only that she return his look. But sometimes she can't, and she looks away or brushes his cheek with her hand, hiding her tears against his shoulder.

His voice is tender, with the merest emphatic touch of humor, as if amused by his own assurance.

Goodness, I do love you, he says.

Kaleidoscope, with Angels

Today they can. As if for a time the angels put by the fiery swords and let them back into the garden. When they make love her laughter begins low in her belly and rises like a river running over rock.

Today every part of their life seems incongruous, amazing, ridiculous. A child's kaleidoscope. So many pieces. The different doctors, the multi-colored capsules with unpronounceable names, the technicians helping him onto the big metal table they push into the scanner that's like an oven with a timer. When the red light goes off, he's done. When he's done they let him out, like the gingerbread boy. And like the little old woman she holds out her arms and says welcome home. He mentions the kindness and skill of his attendants, but he doesn't say what it's like in the oven.

Other fragments, a different pattern: their collisions, their improbable disagreements, her hopelessness, his absurd jokes, his trying. His trying.

Yet today she's able to say it, "Oh, love, you *are* better. Where most it matters, in your heart, you're as close to being well as anyone could be!"

How much falls away! Her insatiable need to know— how long he could live, how and when the tumor started, what they could've done differently, what's expected now, the limits of change. She couldn't know answers doctors didn't have.

But answers make no difference if she can be companion to the child he is. Her own lost and forgotten child comes home in their laughter. Today the angels turn aside while they touch and love each other.

Messages

Once in the middle of their marriage he told her she was trying to peel him like an onion, trying to pry him open as if he were an oyster. As if perhaps only the pearl mattered and not the creature entire that made the pearl possible, its outer shell rough and clamped tight, held together by tough muscle.

But when the salt tide was in, when the cold ocean ran over and around them, the shell floated free. Then all that he was and might be depended on going back to a child on Easter Sunday, a child holding a very large white rabbit; a boy hiding secret messages under the loose shingle of a neighbor's garage roof; the one who couldn't get warm, who shivered under the blanket on hunting trips with his father; a boy resting on the dock after a swim in the lake, his teeth chattering over a candy bar. And the shy young man afraid of girls.

As though he could be getting ready to leave and wanted the scenery in order, wanted her to have his recollections clear. He didn't remember which stories he'd told her and his delight in his memories far outweighed her impatience with repetition. She would help their children to see him whole, the ugly duckling turning into the swan of his favorite fairytale.

No prying now. No shell. Only the pearl, the warm light growing and gathering.

Under the Spruce Tree

Belly-flopping onto the sled—his slatted wood Flexi-Flier with the name in shiny red paint—he closes his wool-mittened hands around the crossbar. It's late, almost time for the call to supper. Time for one more ride. Not much wind. The snow looks like it will come down all night.

The lights coming on turn the houses holy, like church candles, each window an invitation.

He pushes off. The steel runners sing, music that picks up tempo all the way to the corner where his friends call out, "No cars!" and wave him through the intersection. Coasting into the park, he steers the sled to a snow-creaking stop under the low branches of a big spruce.

When he rolls off the sled, the tree sprinkles cold baptism on his face, his neck. He waits a long time in the sheltering quiet, and listens. The voices of his friends seem far away. The snow shines like powdered stars.

He wants to stay here. Not move. Be very still.

But it's suppertime, and he has to pull the sled out from under the dark tree, go back up the hill, go home.

Years later he will remember and find the place, give directions to his grandchildren.

Instructions: Snow House

> his childhood . . . had taken control of him
> now . . . when he turned his gaze inward, it lay
> there as in a brilliant northern summer night,
> intensified and unsleeping.
>
> RAINER MARIA RILKE
> *The Notebooks of Laurids Malthe Brigge*

Building a snow house you have to be careful with the
shovel, dig the drifts easy, don't take a lot of snow at one
time. It's a matter of feel, especially near the roof. Too
much light coming through and it all falls in.

Crawl into it slow, maybe two at a time. When you're
inside, don't move around, just hug your knees and sit
close.

Remember you helped to make this, the walls so dazzling
clean nobody touches the walls. In a snow house you
breathe together, your breath like a cloud hanging in the
middle of the circle.

Nothing to say, it gets boring after a while. But when
you leave and go outside you know you've been in a special
place. Pure and cold. You don't want to talk about it.

Doorway

On the days he couldn't drive, when the seizures had
become realistic possibility, he insisted on taking the bus
so he could finish his work. She watched him go down the
steps with his paper bag of lunch, the pills he needed, his
radio. She thought how venturesome and brave each of
their children looked going off to school.

And she knew she must not now become his mother, but
this was who she felt she was. Anticipating emergencies.
Preparing. Doing what she could. Then all that was left
was to watch from the doorway, to smile and wave and go
back inside the house.

Rage

She wanted to write a cursing psalm, put her anger on the
page where she could look at it. She hated his hovering, his
helping, even his dear pathetic efforts to help her. She
didn't want him poking up the fire or playing host to
guests. Reminding her of his lost convivial presence, the
warm and easy welcome he always gave to their friends.

She hated it when he gave instructions about the car,
about mechanical things in the house. She didn't want to
be trained to take over. She didn't want him telling her
how. Or praising her for all she was doing and doing well:
handling his medicines, the hospital schedule, their
finances, planning meals and activities.

She couldn't be his perpetual retrieval system. She was
beginning to reject his questions, his interests she saw as
hopeless. She didn't want to help him find the name of that
plant in the park, the strange phallic one with fat red
berries. Even now he was able to find something that
interested him. But why identify a plant or a tune? Why
recover the lost plot of the TV show, sort the sequence of
events, get names straight, or directions? He'd forget soon
enough.

She did want him to be independent, but she didn't want
him climbing a ladder to the roof so he could chase away
the pigeons. He seemed to have no sense of danger or what
was appropriate. When she told the receptionist in the
oncology office about his latest adventure, her worries over
his balance, how he could fall, the woman laughed and
said, "A man's gotta do what he wants."

His treatment and care were taking too long. He was

gone from her already, and her rage at what was
happening to them wouldn't fit the neat parallel structure
of a psalm. She couldn't write what was banked deep
inside, like coals. She remembered how the furnace looked
late at night when she was a little girl, the sullen red glare
behind the grated door.

Pieces

She couldn't let all that was happening turn into metaphor
and change her experience, make it unreal, an unreliable
space. What comfort it would be if each event concluded
without the invitation to imagine more, if there were no
other connections.

Then dishes could break without misery. Even this drinking
glass from the pair etched with bicycles, this glass that
their daughter dropped by accident. Just because one glass
of two is shattered didn't necessarily mean he was dying.
He wouldn't die because crystal broke into unfixable pieces.

But she didn't want to use plates or bowls with chips at
the rim. In some small portions of their life she chose,
while she could choose, to have wholeness, perfection.
When they ate soup she gave him the good china spoon,
the blue one with rice grains showing through; she left the
faded dragon spoon in the drawer.

He thought, he still thought, that everything could be
mended, that there would be time to repair the antique
gold and green serving dish his mother brought from
Austria, time to replace the severed head of the porcelain
drummerboy, time to fix the handful of magnets that
needed gluing, to fill in the crack on the pink heirloom
vase.

She named things around her, solid objects in the kitchen:
cupboard, stove, curtains, clock, table. Each looked distinct
and separate, as if it would last. But each was too
connected. To memory, to change, to time. All things were
fragile, vulnerable, apt to blur in the sudden shifts of her
feelings. Liable without reason to fall and break.

Good Company

She watched a man put up holiday decorations at the
neighborhood shoe store. He shook out a paper chain. The
wrong color, a sort of pale brown. He hung it across one
wall and push-pinned the chocolate-colored ribbons to the
ledge near the ceiling. He folded the ends under and
dropped the loops of ribbon in scallops against the wall. At
appropriate intervals by ones and twos he fastened satin
balls like berries in muted pink and dark wine.

She missed the familiar greens and reds. This holiday
was out of season. Death changed the order of events, the
colors. She thought of friends who were dying: Edna, who
couldn't last the winter through, and Morgan. How did his
scans turn out? He was so disoriented when she saw him
last. The middle of the day, and he thought it was night.
Dying enhanced the holiday season, gave peculiar clarity to
words, gestures, objects, ritual.

Her husband must know, surely he must know that his
turn was coming. He resisted what he called her
pessimism. What she called reality. The prognosis a cold
floor, bedrock smooth as ice under each tentative step he
took toward hope he would get well. She knew the floor
was there. Death was closing in, his and all the others.
"Widow" was a word she supposed she'd get used to.

Out of memory she heard words, James Hilton's words
read when she was in college:

Come with me, go with me. I don't know where,
but there are a few of us, we make a good
company already, we carry love in our hearts,
we are not alone.

From the very beginning their promise was to keep truth
alive between them. But she couldn't keep repeating the
doctors' words. The look on his face that first time was
pain enough.

● *Away*

Dark Rye

While she was gone from the house, he rode his bicycle to
the bakery to buy the only bread they ate now. Dark rye.
No wheat. Unsliced.

An easy four blocks downhill, he said. Not many cars, he
said. Adventure he wanted, a test. His first ride in two and a
half years since the brain surgery, radiation, the various
research chemotherapies. His old helmet was too heavy on
his head, so he wore her lighter one.

The ride was harder than he expected, steering a
problem, his legs wobbly over the wheels, his body
different on the seat, not so heavy against the frame.

He walked the bicycle home. Uphill. Taking his time.
The dark bread whole in his knapsack.

Permission

He'd forgiven everything, the past hurts that surprised her
sometimes in her mind. When she tried to make sure that
their relationship was whole and clear, he didn't remember
what had gone wrong. He didn't need to be reminded of
pain he'd let go, all that he had no more need to know.

She cried for the accuracy of her memory, tried to sort
her experience. He said they'd seen their problems through,
and they had. He told her she should feel free to marry
again. She said there was work to do first, so much work to
do. She couldn't say what the work was. Only that it was
all grief, all loss.

After thirty-seven years she couldn't begin to think about
freedom or the great permission of his love.

Away

> Unless I'm wrong
> I but obey
> The urge of a song:
> I'm—bound—away!
> —ROBERT FROST, *Away*

What he rembered he sang—pop tunes from the thirties,
forties, fifties; folk and work songs; old love songs and
hymns; camp and hiking songs. And he asked for her help
with the gaps in his memory.

Delighted at his gaiety, she was annoyed by his
inappropriate timing, puzzled by where he might be in his
mind. She didn't want his little boy or adolescent longings.
How could *Melancholy Baby* reach the deep place of her
grief and despair? She marvelled that she was married to
this amiable child.

She couldn't survive on his saving graces, his systems
and routines, his unruffled coping. If she wanted to laugh,
the tears came. If she was overthrown by anger, tenderness
intervened. She couldn't hurt him by bringing attention to
ways he had changed. How much he was aware, she was
never sure.

His fool's contract was that he would live and be
himself. His faith was in vitamins and his doctors, in
prayer and stress reduction. Her own fool's contract was
that she would protect him from the terrible truth of ways
he might have to live before he died. She wouldn't say
blindness out loud, or hearing loss. Not headaches or
paralysis. Incontinence. More drastic personality changes.

Complexity tired him, and she was nothing if not complex. So much to tend to, not the least of which was her grief over time. Past, present and future time, each part of their life tangled in losses. Not least was her grief for him, her need to find her own salvation on the settled plateau of his illness. She wanted out from under the enormous weight, to be free of everything he asked and didn't know he was asking.

Not yet. Not now. And she didn't expect she would be ready when the time came. But she knew she had passed other dreadful places. With help she should make it through this long business without foreseeable ending.

And on into the future when she would be free to let go—into exhaustion, into storms of weeping her rage at the mystery of what brain cancer and its treatment does to love, to the human mind. What it's doing to him, to the unique, particular, lovable man she'd lived with more than half her life.

His courage was perhaps hardest to bear. He didn't know he was brave. He just kept going. He sang the music he heard, and it didn't matter if anyone was listening.

Signal

His first troubling word. That word put her on guard. He
had to reduce it to syllables, go back to the original parts of
speech. That word broke everything into the open, made
them vulnerable.

He asked about *signal* one night before sleep, asked if
she noticed him having any problem saying the word. She
said it was all right. She had noticed, but she understood
him, and it was all right.

Were these the syllables directing them to the future,
toward that place she couldn't imagine, the place the
doctors said might be ahead of them?

But after that one word, that signal, they went back to
living their lives. The new green spring softened the days,
and it seemed as if not much had changed.

Reading the Map

He was the one to decipher timetables when they travelled
in foreign cities. When they drove he read the maps. He
learned new routes quickly, explored backroads by happy
intuition, arrived at the right place without difficulty. She
said her poor sense of direction might be inherited.

But the map reader's lost. He can't be counted on. When
tourists want information, he's forgotten the familiar
roads. The streets are becoming a maze, puzzles that no
longer challenge or charm him. When he can't figure out
the zip code area map, he says he doesn't really care and
closes the telephone book.

They're learning new ways to travel. Neither knows
where they are going, but they trust Machado with their
lives. The poet said "We are making the road together."

Wanting

Out of everything she wanted, she wanted him the way he used to be, wanted the old otherness against her, wanted *him* to help her take care of him the way he was now. And he wasn't available. He'd gone off and wasn't likely ever to return.

Once or twice she thought she saw him, for a moment caught a glimpse that was bright and appealing. They talked with affectionate familiarity. But it wasn't long until the fog took him. He couldn't stay.

Gulls

They watched the gray and white gulls come in, wings translucent against winter sun, patterns of cartilage and feathers exposed in intricate design. Shadows deep in the wings, like x-ray film.

Flying low, barely skimming the water, the birds broke the surface to small v-shapes behind them.

He didn't say so, he didn't have to tell her. She knew he found rest looking at them, a kind of peace.

In her head she heard a poem read years ago in a book that belonged to her grandmother:

> Pain has been, and grief enough . . .
> All there is to see now
> is a white bird flying . . .

Above the gulls, louder than the gulls, she heard the cry in her heart:

> Let go, let go. Even from me.
> Into space and light

Tunnel

Her father's first off-balance fall. He was trying to throw a
paper airplane for his grandson, said he simply turned too
quickly, too soon.

The next day Karen went with him to the park where
he'd taught her to ride a bike, past the softball diamond
where she and her brothers used to play. The dog ran
ahead into the tunnel. The big initials were still on the
concrete wall, letters squeezed out of the caulking gun
Dave borrowed from the toolbox. New generations of
graffiti there now, other claims to territory.

Because her father asked her, she yodelled for him in the
tunnel. She knew that if ever there might be a way through
for him after last night's fall, the dozen stitches above his
eye, after the seizures he'd had, and more coming, this
might be a way. Maybe yodelling could be their private
spell against further harm, the night chill just beginning,
the spring solstice he talked of welcoming too far away,
impossible to imagine.

When she yodelled, mountains came to her mind, and
green Marin County hills from that photograph he'd taken
when she and Brian struck those foolish poses, clowned
their way through choruses from *The Sound of Music*.
When she yodelled, her father tried to sing the echoes back.
But his voice was different. The dog stretched his neck and
howled. They broke into giggles, and there were
reverberations she didn't expect: she was a little girl, she
heard lullabies, family singing in the car, all those trips
across country. She remembered Rocky Mountain
campsites under the stars, granite ledges around lakes in

border country, canoe paddles dipping to songs of the
voyageurs. Music from a cavern below the surface of her
mind. Deeper than memory, an underground well.

She wanted him to sing for her. She wanted his songs for
her children. He asked her to yodel a second time, and she
couldn't. She didn't trust her voice to reach those high
falsetto ranges. O, the melody was there, the meaningless
syllables there, the abrupt changes surely there. But
everything would break if she tried.

Oncology Office

She was here to pick up his scans. "Old Sludge" was back, and there would be another surgery. Between phone calls, the nurse stopped to talk. There was little to say; over the three years they had asked all the questions.

A mother came in with a baby. The nurse said, "This is my next patient," and she asked how the baby was eating, how much he weighed. "We have to know to measure the medicine for treatment."

His mother unwrapped the child and guided his arms free of the blanket. "About nine pounds," she said. "Eating about the same. He's four months old."

The baby's head wobbled on his neck, like a flower on a stem. His eyes were large and very dark. One side of his head was scarred by a neat incision where his tumor had been removed. The baby tried to smile, tried to hold up his head. The nurse said, "It's a tough time, isn't it, Marcus? A tough time. I know, it's hard."

The woman watched and listened, and tried not to. There were no words she could think of.

When the large envelope with the scans was ready for the surgeon, she said goodbye to the nurse and walked toward the elevator. Again she was reminded: hospitals are good for us. They connect and give us perspective. She felt an immense gratitude she'd never be able to say to the early research patients who tried out the cancer treatments, the new drugs. Those who lived for months so that already he'd been given three years.

Maybe his time, his enduring time, was for someone they didn't know. She had to believe in some kind of possibility.

Collage

A week before the second surgery, on a day he was weary
and ready for a nap, he smiled and said to her, "Down goes
Henry to the bottom of the sea."

On the wall facing his bed in the hospital there's a
collage made from tissue, burlap, tweed and paint. Blue,
green, gray and gold, a flat print really, the appearance of
texture quite deceptive. A large sailboat rides the left
center; in the right corner a seagull sits on a black piling
near green and blue triangles of water.

Death Angel sits on a rock and says, "Take your life and
build a boat." The angel doesn't give directions, doesn't
spell out cubits or destination. This single instruction is all
he gives. But he'll be here for the launching, push the craft
from its moorings.

Mistake

Nothing was left but to bring out the scissors
and cut the beard . . .
 Snow White and Rose Red

With his bare stubbly head and the dark half-moon
incision blanket-stitched in his right temple, he looked
naked enough already. Given the indignities of two more
brain surgeries, respirator, catheter, peristaltic pump with
the bizarre name of Kangaroo 220, given his loss of speech
and ability to turn over in bed, why couldn't he keep the
stubborn vitality of his beard?

Standing beside him, she could hold his one good hand.
Sometimes he squeezed back. She could rub his feet and
legs, put her cheek against his and play her fingers through
his beard. She liked the way it sprang up alive under her
fingers.

He'd grown it first in the navy, before they were married.
He told her the color came in a surprising red, that when
he walked in the door at home after three years' service on
the hospital ship, his brother-in-law said all he needed was
a parrot on his shoulder. He grew a beard again for the
Colorado centennial, then in the sixties, and now. For
several years now. He said a beard kept his face warm,
saved shaving time and energy. It strengthened the good
bones of his face; people told him he looked like Lincoln.
He liked his face that way.

She thought of bringing scissors to the hospital and
trimming his beard. Maybe take a curl to save, as she'd

saved the children's hair, the fine webs tied with ribbon and taped in the baby books.

But a nurse cared too well for the wrong patient. Coming in early on replacement, she bathed and barbered the wrong man. She didn't check the name on the plastic wristband. All an unfortunate mistake. No record of an order in his patient's log at the desk in the neuro-observation unit. The nurse was in tears; could the family forgive her?

The supervisor told how it happened, how it shouldn't ever have happened. Everyone was upset and kind and sorry.

She wanted to rage at every single one of them, wanted them to know how she felt, how this mistake made her feel. But she could think of nothing to say. Her confused feelings, her private connections and memories didn't belong here, in the hospital. This wasn't the place, and there wasn't time.

Into the Sea

She went to the library to return the books he'd been taping for grandchildren before the operation. A movie was showing, and she sat down for the final scenes of *Paddle-to-the-Sea,* a book she'd read to their children.

She watched the boy on the screen, the Indian woodcarver. From a high cliff he dropped his wooden canoe with the solitary figure, and it fell a long way into the gleaming water. The small boat righted itself and the carving moved out, carried by the waves.

Tomorrow she hoped she could tell this story, hoped he would hear. Maybe it's time, love, time for paddle to the sea, time for the great cliff and your life going over. Into the big water.

Then the lights came on, the sounds of excited children's voices hummed around her. When she went outside she couldn't see clearly, but she was aware of late afternoon gray on her face, the rain still coming down.

● *This Body of Words*

Exorcism

The bed is gone, out of the dining room. The room is
returning to itself, the TV tray cleared of hospital tape,
bottles, measuring spoons. Suction catheter and ng tube
gone. No more medicines. Morphine Sulfate,
Dexamethasone, Dilantin, Tylenol—all emptied down the
toilet, the official dumping witnessed and signed for.

The oak table inherited from his parents is restored to its
original intent, a gathering of kin. The family is eating
again. After the starving days of his dying they could do
little to change or ease, they are exorcising this room in a
celebration of freedom. They are cleansing this place of his
agony.

As if by being together they will erase the stunned
bewilderment in his eyes, his painful efforts at speech that
gave them only three words. Stop. Home. Mama.

As if they could by their singing heal his throat and
chest, end his coughing and bring song up and out
through his choked and infected air passages, turn his
paralysis into their dancing. They want him among them.
Alive and whole and young. And they know it is too soon.

Medical Research

His body was searched to its most secret cell, his muscles
and bones examined, the exact chemistry of fluids and
secretions tabulated and recorded. Nothing was refused to
the probe and the scalpel, to saw and mallet and chisel, the
glass slides, the microscope. All was given over: to details,
notations. Broken and divided, his body was accounted for.
He had willed himself wholly, and what could be learned
was learned.

The signed agreement said: "No questions will be
answered. Nothing will be returned."

His ashes weren't given back, could not be scattered in
any loved and chosen, *particular* place. Not in the
mountains or redwoods, the garden. Not in the Pacific
Ocean he took so long to turn away from one morning the
week before the final surgeries.

Leaning against a rock at the trail's vista point, he made
a visor with his right hand, shaded his eyes while he looked
and looked. Down the mountain, and out at the immense
bright ocean. A great distance seemed already growing in
him. Almost inaudibly he said the words, "It does go on
and on."

His life returns many times. His remembered body is
dismembered and buried. Many times. There is this
assurance: his devotion to the findings, where fact might
turn into healing.

Redwood

Light takes the Tree; but who can tell us how?
THEODORE ROETHKE, *"The Waking"*

He said he wanted his life to be like a redwood tree.

She thought of the great age of redwoods, how long *they* live, trees in family circles, two trees whose crowns come together so high they look like one tree when the wind moves. She remembered a photograph of the children seated on redwood roots near a campsite at Big Basin. How long ago and small they look, how small everyone is in the ancient forest.

A ranger told them that after fire these trees heal themselves. New wood begins in the cambium layer, fallen needles turn to duff, they cushion and feed the ground. Roots are near the surface and we shouldn't walk too close.

Everything seemed full of important meanings, a code she couldn't break.

One day after he died she saw him sitting on a large branch growing from the trunk of a redwood tree in the park. He looked like an old druid, and he was laughing.

Here and There

Here empty branches, crabapple, plum, refuse the winter
season of her mind, and flower, vivid as that morning she
wanted to do a painting and couldn't make the sky the
right blue or find a color true to the trees.

Here's what's left of the Monterey pine uprooted several
years ago in heavy wind. A huge tree wet and glistening
that blocked the path. They sawed off a branch and hauled
it home, the best Christmas tree they ever had, a green so
nearly black with great round cones in the long needles
that clustered full as little bushes. And somehow, birdsong
in the bough.

Here the waterfall rushes down the artificial rocks they
watched the workmen shape out of wire mesh and
concrete. What she watches now turns into a double
exposure, a picture he took too many times in northern
lake country. So much love, so many September berries
they wanted to eat them all. All that water running over
real rocks. He forgot to wind the film, and the waterfalls
run backward and sideways, splashing into each other.

Here a white heron stood in the weeds at the edge of the
lake. Every morning in the same place for a week. The day
it wasn't there the empty water told her some other creature
would bring news she has to go on translating.

Here's the picnic table where they brought lunch one last
late summer afternoon, and took their own sweet time. He

said then that in his life he'd paid too much attention to *causes,* movements of protest in the world, that it was time now to look at the light on the trees.

Here's the half log they leaned against and asked a passing couple to take their picture. How tired he was. How long it took to walk home.

Later

Walking on the trail, she circles grief like an animal.
Coming on a great stump of redwood, she sees it's an altar
overgrown with moss and lichen, a sliced-off altar with the
step too high for kneeling. Three guardian trees stand
behind it, and dry brown needles cover the flat surface. The
roots go down like green feet, soft-furred. There's poison
oak at the base.

She talks to the forget-me-nots in the grass. As if she
could, or would forget him. He's tangled in her life like the
stickers of the vine. He's in the rough songs of the crows,
in the music of other birds.

He comes up every day with the sun and she falls asleep
saying his name in the dark. She says his name out loud
because she wants the sound of it in the room, needs to
verify his place in the world the way photographs verify
the shape his body had, reassure her he looked like this and
wore these clothes. She reminds God of who they are in
case God forgets.

But she can't get back his smell. After he died she went
into his half of the closet and breathed him in. She touched
the indentation his elbows left in the sleeves of his blue
corduroy jacket, the folds of the brown vest he put under
his neck or draped over his head when he was cold. That
vest he lost on a hike and she went back to find it for him.
She looked at the knee hollow in the legs of his jeans, the
prints his body made. No body was or will be that shape
again.

The last time she saw his body he was in the canvas sling
the men from the mortuary rolled him into when they took

him down the front steps very early in the morning the first day of May. The grown children stood behind her, silent and crying, glad he was going, glad he finally had let go of the body that held him. They were beginning to hate his body that continued to betray him. They didn't know why he stayed. She told him there was only water and morphine, she told him she would be all right, that he should go. He couldn't answer. Three times the nurses said he was dying, but he didn't die. He had his own agenda.

It's a year later, and she's walking in the woods. Their bedroom is being painted while she's away. After twenty-six years the old aqua is changing to white, the trim turning blue. Silverpoint, it's called. She likes the name, she'd like to tell him the name.

Brushing mosquitoes off the pages of her notebook, she remembers that you pray to the Buddha while you kill mosquitoes. In this life that's how it is. The insects fall off her hands, she wipes away blood streaks from her skin. The swelling begins. First the itch, then the swelling.

The first night here she walked up the hill, alone and crying. Nothing she could say to anyone. Her loneliness had nothing to do with people. After a while the stars grew distinct again, and bright. Her flashlight told her where the edges of the road were, where the weeds began.

They'd often come here together. She's heard that it's easier if you go new places, do things you never did with your husband.

There's so much she wants to tell him. She makes notes so she won't forget, so she won't forget her life, all of her life she wants to tell him later.

Termite Inspector

He comes to the big house that is all hers now. Papers say
she owns it. She follows him through the rooms where he's
hunting signs of termites, wood beetles, dry rot. She's not
sure what she's looking for.

He directs his flashlight along the floors, walls, the
ceilings. He turns on the water to check for leaks in the
plumbing. He tests suspicious-looking wood with his long
screwdriver and appears to be satisfied when the probe goes
in and the fiber crumbles.

In the basement she asks if he wants her to turn on a
light, but he says it would make too many shadows. She
sees her husband's tools on the workbench, his gloves
where he left them. The inspector makes notes for his
report and she puts down a few words on scratch paper.
Reminders. She's trying to learn; she's even found the
twenty-five-year-old original report from her husband's
files.

He tells her the place is in good shape. Fine foundation
work, but a funny reverse slope to the roof of the sunporch,
the room her husband added to the house. Connections
there need flashing and wet patch. And there's soft wood in
the risers of the back steps he never had time to replace.
The inspector says the backs of steps shouldn't be painted.
You have to let the wood breathe.

The inspector is thorough. He looks into closets and
cupboards, behind storage boxes and camping equipment.
He says he could talk for hours about termites and never
repeat himself. He mentions the danger from imported
baskets and wood, how firewood belongs outdoors, away

from the house. He points to the clean round holes left by
wood beetles in the stump of cypress he tells her ought to
be split and burned. He shows her a nest that wasps are
making under the eaves.

When he praises the obvious care this house has had, his
words go straight past her to the absentee owner whose
name has been taken off the deed of trust. She holds the
deed of trust, and when she says thank you she's sending
his words of approval a long way.

The termite inspector posts the certificate on the wall.
After he goes, she picks up a broom to sweep the basement
floor. She begins to clear the workbench. But first she tries
on the leather utility gloves with their split seams and the
holes worn into the fingers, the thumbs. The gloves are
stiff. Much too large for her hands.

No Code

When Anna tells her that her husband also died at home ("A good death," she says, "beautiful") she wants to *make* Anna listen to *her* story, wants to shake her till she hears.

Her husband's death wasn't beautiful at all. Not good, unless it was the beautiful morning it was over. What she wants to say is: ugly. Terrible. Too long. She wants to say they hoped the morphine worked, hoped he knew they were all there and loving him, even if they couldn't stop using the suction tube or he would drown. They had to pull the staph infection out of his throat. The hospice nurse said that with his fighting spirit he might take days to drown. Not a good way to go, the nurse said.

And he had to have liquids if the drugs were to work. They couldn't take out the feeding tube unless they gave regular shots, and they wouldn't bother him with needles. He needed all his attention for the concentrated work that engaged him: going out of his life.

She didn't tell Anna. It feels like no one is able to hear.

On Tape

She plays the tapes to have his voice in the air, reassurance
from waves and vibrations. His voice that keeps her warm
and tells her he was here. Once, and for all the years they
had. That time *was* real; she has to know that time was real.

It's his pulse she's after. She wants to match the blood-
beat in her wrist. She wants the timbre of his voice filling
that space. She listens. He's trying to remember: "I think
this one is . . . Roumanian . . . " There's the familiar click
where his voice stops. She doesn't know the song he meant
to sing.

The thin ribbon winds down into the flat container. She
puts the tape away. She knows she can count on this.
There will be no difference in his voice. He will say over
what he is saying now. No other song or words.

She's learning to love plastic, the ninety synthetic minutes
that bring him to her stumbling and sweet in his speech, in
riddles, music and stories he retrieved from his stubborn,
fragmented memory. For the grandchildren, he said.

Lying on the living room floor, she listens to the tapes
while she does her back exercises where he did his when he
was here and took such good care of his body. He amazed
the nurses who found him on the floor by his hospital bed
the morning before that last brain surgery. Doing push-ups
and knee-bends and a long stretching out.

"It never hurts to try." Even his clichés come back in the
failed language that may be true.

Letting Go

He said the hardest part was giving up his will. Letting go of his own will and admitting that whatever was going to happen would happen. After he and the doctors had done what they could, to be able then to give up plans for his life, his future. To surrender. Not to the tumor, but to the mystery. Where he was going. Where he was headed.

She's being asked for a similar surrender. Now he is dead, she has to let him go. Finally she has to let him go and take their future with him. She has to say never. Permit the unadorned fact its true existence, not allow it to be twisted into unreality by feeling and memory.

She doesn't know what this may require: perhaps the rest of her life.

This Body of Words

Was his life then to become legend, a handful of incidents
and ancecdotes to accompany the tapes and photographs
that fix him forever in place and in time? Nothing could be
added to his life that changed in the telling, distorted
already by looking back, by her trying to tell what it was
like, how she felt.

Even the necessary changes in their house, the sorting
she had to do, giving away his clothes, the books and tools
he would want someone to have and use. Even moving the
furniture, painting the walls, putting down the new plum-
colored carpet. All these set his death absolutely. She
couldn't get back to him; the changes pushed him away.

If she could remember and imagine with some clarity of
truth, maybe he would return and be the person she loved.
Writing, putting it on paper, might keep him with her a
while longer, alive a little while longer. She wanted to give
him this tangible body, but she didn't want words to be his
museum. He didn't like being on display. It would be
awkward at first, but he might get used to this new form,
this shape that couldn't hold him. This body of words.